the Good Shepherd PSALMS 23
Yongsung Kim

The Lord is my Shepherd
I shall not want

He maketh me to lie down in green pastures

He leadeth me beside the still waters

He restoreth my soul

He leadeth me
in paths of
righteousness

Yea though I walk through the valley of the shadow of death

I will fear no evil
for thou
art with me

Thy rod and thy staff
they comfort me

Thou annointest
my head with oil
my cup runneth over

Surely goodness and mercy shall follow me
all the days of my life

I will dwell in the house of the Lord for ever

Coming Soon - Spring 2017

The Hand of God book

Now Available

(2) 4.25" x 5.5"
Card Sets
6 assorted cards per set

(2) 3" x 4" Mini Card Sets
12 assorted images per set

500 Piece Puzzles

12 x 12 Calendar

LIGHTHAVEN

1.800.366.2781
www.LightHaven.net